D1175649

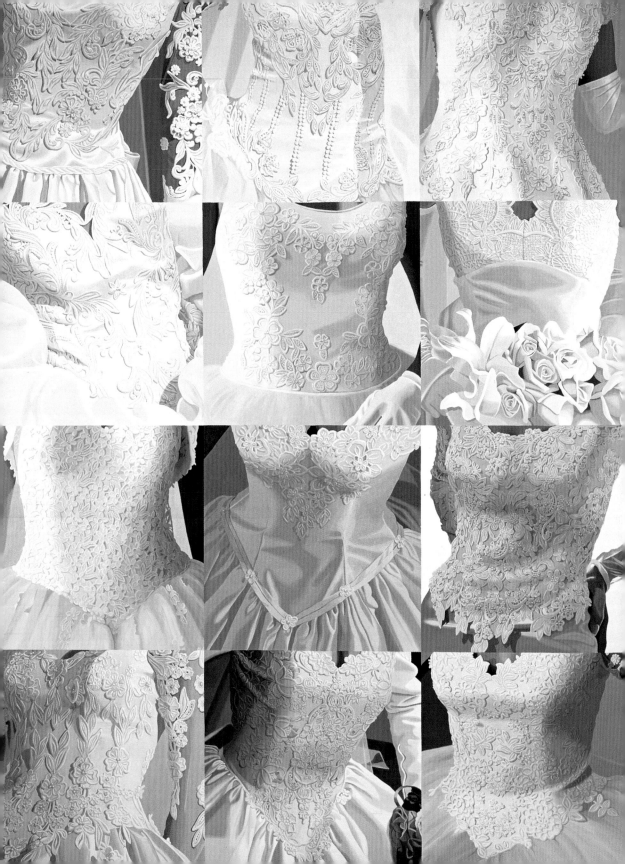

JULIA JACQUETTE

I DREAMT

IAN BERRY

THE FRANCES YOUNG TANG TEACHING MUSEUM AND ART GALLERY

AT SKIDMORE COLLEGE

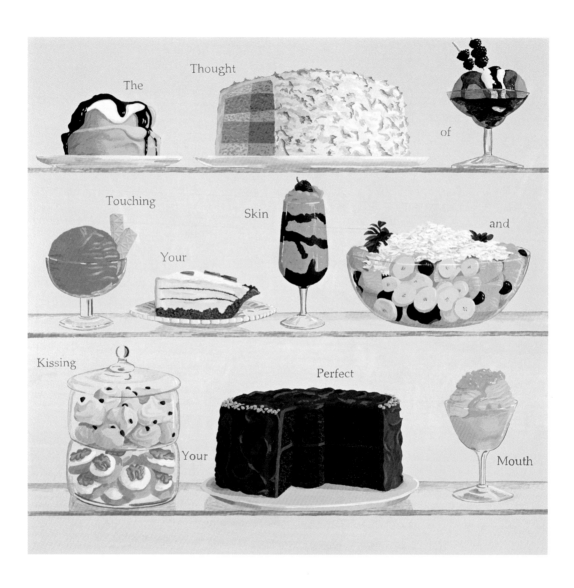

I DREAMT

A Dialogue with JULIA JACQUETTE by Ian Berry

Bakery-counter cakes, gleaming wedding dresses, glistening women's lashes, and plump hors d'oeuvre platters shine from within Julia Jacquette's glossy enamel-on-wood pop paintings and her most recent large-scale gridded canvases. Desire and memory are found in her focused look at middle class Americana and its cultural reproduction through advertising. Her coupling of suggestive texts with "innocent" cream puff pastries and her idealized visions of the trappings of traditional weddings unmask the confusing cultural attitudes towards gender and longing, as pertinent today as it was fifty years ago.

IAN BERRY: Many of your paintings begin with your memories—tastes, smells, and the feel of skin, for example. Can you talk about some of those sources?

JULIA JACQUETTE: One strong visual memory is from the New York City Ballet. My mother brought me to see the Nutcracker for many years, and I actually dreamed as a very little kid that I wanted to be a ballerina, but that desire was expressed through visual art because instead of dance class what I liked to do was draw pictures of the ballerinas. The Balanchine production of the Nutcracker was filled with extreme visual delight for me. One of the scenes that I am still riveted by is *The Dance of The Snowflakes* where they are holding these funny kinds of pom-poms, which make it sound corny, but it is quite elegant and beautiful. The dancers wear very simple white, long tutus and there is fake snow falling on them. It verges on being too pretty and silly in a way, but with the Tchaikovsky music and Balanchine's choreography it is gorgeous. That was one of the first all-white spectacles that I remember. Also, in the second act dancers dressed as different kinds of candy dance for the prince and princess. Giant, white, tiered candy dishes that are supposed to look like Victorian

(facing page)
Your Perfect Mouth, 1995
Enamel on wood
24 x 27"
Collection of Maja Hoffmann

(previous page)
Wedding Dresses, 2001 (detail)
Oil on linen
72 x 72"
Collection of Richard and
Lisa Perry

pressed metal candy dishes with huge painted candies in them come down as a backdrop. It is funny how just that one ballet encapsulates so much in my painting.

Another vivid memory is my First Communion. My mom dressed me very simply and elegantly in a pink linen chemise dress with very little embellishment, except maybe a bow in my hair and that was it. When we went to the church there were all these little girls in what are basically miniature bride's outfits, with veils, tiaras, lace gloves, and even white lace socks. I was livid that I didn't get to wear that—that it was a possibility I didn't have. White, decorated surfaces have been a visual fascination for me for a long time.

IB Didn't your father's architecture also form a strong visual memory at that time?

JJ Modernist architecture of the 1970's, which I lived with through my dad's architecture magazines and journals on the coffee table, was another one of my great "white" influences. My brother and I looked through them frequently, and they were very engaging for a kid. They are filled with photographs of buildings; most memorable were the Richard Meier homes, which were incredibly appealing to me. Lots of all-white exteriors and interiors, lots of light—as a child they were incredibly warm looking.

IB They weren't cold and antiseptic—like much of that style can seem on the surface?

JJ To me, what was antiseptic was the suburban ranch house that we would occasionally go into visiting friends. Our own apartment, which was filled with classic pieces of modernist furniture design, was in a tall monolithic late 1960's apartment building—it was an incredibly warm environment. Although in many ways I react to modernism, maybe I am critiquing it somewhat in my work. I actually have a great fondness for it, and so my paintings are also

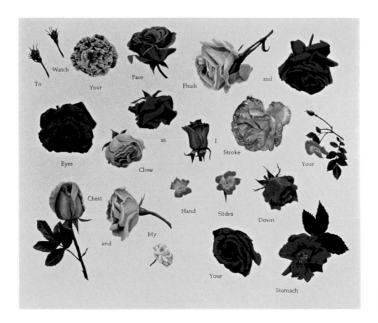

To Watch Your Face Flush, 1997
Enamel on wood
22 x 26"
Private Collection

an homage to that time in many ways. As a kid, it offered a great
working environment. It seemed like the homes that I was looking
at in *Progressive Architecture* would be a great place to play in,
to make stuff in. They offered great possibilities for creativity—
whereas the kind of suburban tract house seemed kind of
deadening and set.

IB It was a stage set where you could live in your imagination.

JJ Yes, and although I was not in any way brought up in the
suburban tract house, I absolutely reacted to that look and that
way of life.

IB One of the first paintings in this show is *A Watched Pot*, a
painting of a black telephone on a wood grain tabletop. When
you describe the Nutcracker one of the great things about that
story is the tension and anticipation of what is going to happen...

JJ Absolutely.

IB Anticipation not only about what will happen but what could be. This comes up in your memory about First Communion, and overtly on the surface of *A Watched Pot*. Do you think of that feeling when you paint?

JJ Yes, and I would modify it slightly in that it is anticipation with a lot of anxiety that what is desired will not materialize. I think that telephone painting is the epitome of that. Almost all of my work that has recognizable imagery in it are things that I would actually like to possess, and have a lot of anxiety about not being able to get. The act of painting them is in a way my version of getting them. A reference I often cite is from the children's book *Harold and the Purple Crayon*. In that story the hero, Harold, is able to draw a landscape and walk into it, draw a pie and then eat it—that was one of the first children's books that I had, and although I think I would probably be making this work even if I hadn't seen that, it probably suggested to me that idea of you can make what you want. Sure it's only in two dimensions, but you still get to have it.

IB You not only paint objects, but also romance and other idealized moments—you want all sorts of things in these paintings.

Four Women (All Touching Their Face), 1997
Gouache on paper
7 x 22.5"
Private Collection

JJ Exactly, in fact I see the food paintings as both desiring food, but also as a metaphor for a huge number of things, romance, sex, desire, and so on. Food was the first imagery and then images of

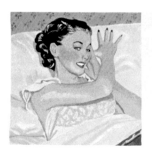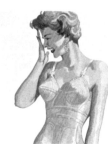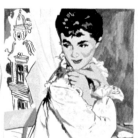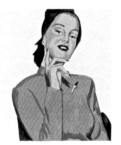

jewelry were also at the very beginning of these works. They were the first visual metaphors I used to talk about longing.

IB When you say first, are you talking about college?

JJ Graduate school. I was certainly painting a long time before then, but the body of work that I am still working on now started then.

IB Was there an influence there, fellow students or professors that were important or that you remember?

JJ I was certainly interacting quite a bit with my fellow students and faculty, but I think it was a realization that I wanted to make work that didn't look like something I was already seeing. At that point I was making paintings that were directly influenced by Philip Guston, and I finally came upon some visual ideas that I felt would be interesting. The first thing I did was a painting of a field of rings, all these gold rings lying on a surface. They looked like ladies' engagement rings. As I started to make the painting, the greater meanings embedded in the imagery revealed themselves— that was a big turning point.

IB Guston certainly had a great affinity for isolated objects existing as a symbolic alphabet.

JJ That is why he is still so important to me. He is a great example of an artist who created a personal language. It is funny to think at first I was borrowing his language and finally found my own, but it was through his example in many ways.

IB While Guston found his symbols around his studio, you found yours in advertising, and magazines. How are these potent sources for you?

JJ I think this kind of imagery is omnipresent for women. The fashion press encompasses a huge world of imagery that is transmitted to us through signage, television advertising, and mail-order catalogs. An important visual influence in my early work was those department stores ads that come as inserts with your Sunday newspaper. I got a lot of imagery for the early jewelry pieces there, and was simultaneously finding food imagery from package design.

IB Logos, ads...

JJ Logos, things right out of the supermarket like cake mix boxes. Also women's magazines and old cookbooks. I am particularly drawn to cookbooks from the 1950s because it felt like that style of food is still what we think of when we think of Sunday dinner at home.

IB It has become the ideal.

JJ It has become the ideal, and I think we still hold that in our minds even though most of us may not have pot roast on Sunday night. But I think still when somebody says the words "Sunday dinner" to us we think of that checkered tablecloth and the turkey or pot roast and apple pie. So, I also chose images that were somewhat iconic, I wanted signs for, or symbols of, the food in general. I was starting to collect a lot of old cookbooks, fashion magazines and women's magazines, because soon after the food, I also started doing the paintings of women's eyes and those were taken from fashion magazines from the 1950s to the present.

IB Although your subjects are somewhat timeless there does remain this moment of America in the 1950s that you return to. Is it your idealized fantasy of that time, or is it a sort of pulp fiction novel reality where romance was sweeter and bigger then?

JJ I feel like the ideas and ideals of that time are the ideals we actually hold onto now, even though so much about our culture

has changed. I still think that in almost all of us there is a clinging to some of the notions of how men and women should be and act deep within us, and deep within the culture, even if some of us don't like to admit it to ourselves. In many ways my paintings are trying to exorcise that for me.

IB What happens in the paintings that exorcise these things for you?

JJ I get to own that imagery, and once I'm messing around with the images it is a tremendous relief.

IB I want to ask you about your *Projects* exhibition at the Museum of Modern Art in New York. It was a tough moment to have an exhibition at the museum as they were moving things around within the building. Your solution of making a project for the café was a great way to take that series to a greater number of viewers than some of the shows do in the gallery spaces. How did that show come about—did they invite you to work in that space?

Hot Dog Platter, 1997
Enamel on wood
20 x 28"
Collection of Michael Corman and Kevin Fink, Dallas, Texas

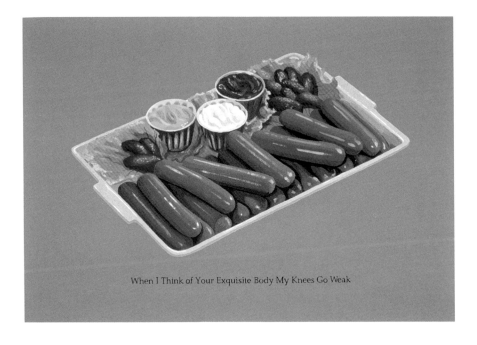

JJ They invited me to work in the café, and the idea of having paper products designed by an artist came from the assistant curator, Judy Hecker. It was in 1999, and she presented the idea to me of designing paper goods for *Café Etc.* At first I was taken aback because I had never considered doing paper products, but the more she talked about it the more I realized that actually this could be a very good fit. At the time I was trying to figure out a medium that I could possibly use for public art projects, and I wanted to figure out a surface that would be right for my ideas. As soon as it clicked I knew exactly what I wanted to do. It was right at the tail end of my food work, and I loved that now I had an opportunity to bring that imagery into making this gigantic multiple.

IB How many were produced?

JJ Tens of thousands. It was only supposed to last three or four months, but they had luckily miscalculated how long the products would last and so they stayed in the café much longer. I think it lasted over a year. They also had some of the products available in the design store, which was a great thrill.

IB Eating is such an everyday thing, but it's actually a very intimate act, and we don't often watch each other eat. It's a private act into which you inserted these provocative words. The words that you chose are a combination of words that you used before, and had revisited a couple of times—where did those words come from?

JJ I had to write a phrase that would work as a full statement when one had all the different products on their tray, but would also work if it was in sections. In other words, if you just had a coffee cup, the chunk of that statement would work on its own. I think the greatest influence for the text is Oscar Wilde's play *Salome*, and where I really saw the full play was in Ken Russell's movie version, *Salome's Last Dance*. There is a famous monologue that Salome has, reciting to John the Baptist who is in this dungeon-like hole in the ground. She goes on about his lips, how she wants

to kiss his red lips and all his different body parts and how she desires them. A few years later I started including text in my work, and Wilde's play informed the rhythm of the phrases that I was using. Another text influence is Magritte's use of a single word or phrase in his paintings.

IB …under a floating object.

JJ Exactly. Another big influence was the paintings of Frida Kahlo in which she would include text. There is one where she is sitting in a man's suit, and she has just cut off all of her hair and at the top of the painting she has painted part of a song, and it says something like "if you love me it was because of my hair, now that I've cut off my hair, you no longer love me." It is directed at Diego Rivera, and that painting was so impressive to me as a kid because I had a reproduction of it in a book about women artists. Although it may seem like the artists of the 1980s who used text, Jenny Holzer or Barbara Kruger for example, were an influence, I actually was reacting to the impersonal feeling of that work. I looked more to Kahlo who is quoting but speaking directly about her immediate experience.

IB In contrast to some artwork of the 1980s, I think your paintings are a combination of the homey and the erotic, and by keeping the work intimate, either by scale, or subject matter, you can access both of those strands at the same time to make something very unsettling.

JJ I am glad you think so because it certainly is about locating that intersection within myself. I don't know how to make work that isn't about revealing my own weakness and my own desires. It seems like everything has to come from that.

IB Is that ever uncomfortable for you—inviting people to see your desires?

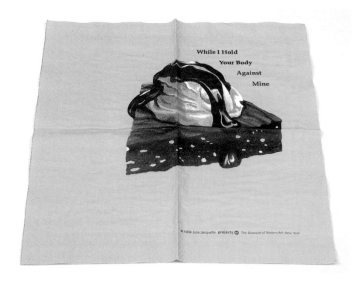

Projects 69: Julia Jacquette,
1999 (detail)
Printed paper products
Various dimensions
Unlimited edition designed
for the Museum of Modern
Art's *Café/Etc.,* New York

JJ No, what would be uncomfortable for me would be putting on a veneer of confidence.

IB What you may see as moments of weakness or moments of uncertainty are very strongly stated. Have you ever made a work that you felt was too revealing that you didn't end up showing to people?

JJ No, although there are a few pieces from the mid 1990s that have roses in them, and my strategy in those was to have the text be very suggestive sexually in order to counter the insipid image of a rose because it is so over used. The text was highly sexual, but not explicit. When I show them now everyone giggles.

IB That uncomfortable laughter is what they are all about. Even between your figures you can feel the anxiety. They are perfect movie stars, detectives and starlets, but they are having moments of uncomfortable jitters about what is going to happen.

JJ Well said. One thing that I have thought about a lot is making work that is about desire and about sexual desire and about the desire to objectify without that being at anybody's expense. In

other words, I didn't want to just flip around the tradition of paintings of women as ways of possessing them or as objects. For me it was a project of how to paint about one's sexual desires without objectifying the subject. That was another reason why I so wanted to find a vocabulary of imagery and a vocabulary of visual metaphor.

IB ...that wasn't a nude, that wasn't a model, that wasn't yourself. Was there a moment when weddings entered the picture as material ripe with possibility?

JJ In 1996 I made a few paintings that were close ups of wedding dresses when I was still using sign painter's enamel. They were in my second show at Holly Solomon's Gallery in Soho. I had always wanted to tackle the idea of an all-white painting, and I was very pleased with how those two came out, although they were quite difficult to make, especially using the enamel which dries so quickly. I put the idea aside for a while knowing that I would need a good chunk of time to make these paintings large and to do a number of them. As fate had it, just as I started making those paintings Holly closed her gallery. That was a tense, sad, and agonizing time. I had a couple of years after that where I hibernated in the studio and didn't have people look at the work until I felt there was enough of it to be called a body of work. The idea of making an all-white art object has been kicking around for a while. It has been an ongoing obsession since I was a kid.

IB You got married at this time. Do you feel like you have a greater appreciation or a greater distance from these works now? Do you want to make more of them, or are you done with them?

JJ I want to make more of them and am going to continue for a while because now they sprouted this other arm, so to speak. I started saving the paint from making the wedding dresses, wedding cakes, and flowers to make geometric abstract paintings. This is a whole other idea that interests me. At this point I am going to continue the white work in that dual nature and then maybe the

idea of making two different kinds of paintings from the same palette in itself will become something. Getting back to the idea of weddings—I think I was always simultaneously fascinated and put off by the idea...

IB Repulsed?

JJ Yes, repulsion is the right word. Repulsed by the idea of the big American wedding with an expensive dress, but I love the way that stuff looks. I think that since I was exorcising it out of myself by making the paintings, I felt I didn't need it in real life. In fact I adamantly avoided it—I had a very small wedding, I didn't wear a white wedding dress, and I didn't even have a white wedding cake. I had chocolate, which is what I really prefer. I think that I lived out the desire for the most elaborate white dress in my work.

IB How did the anticipation compare to the real thing?

JJ It stayed the same because it remained this sort of dream that I hadn't been in yet and didn't really want to be in, yet was fascinated by. So, actually with great glee, I stayed in this anticipatory state that I knew, actually happily at this point, that I wouldn't ever get to. Instead, I had the reality of a very happy wedding that was totally unlike my imagery. I am in this anticipatory state that will never be satisfied.

Joan, 1991
Oil on wood
24 x 24"
Collection of the artist, New York

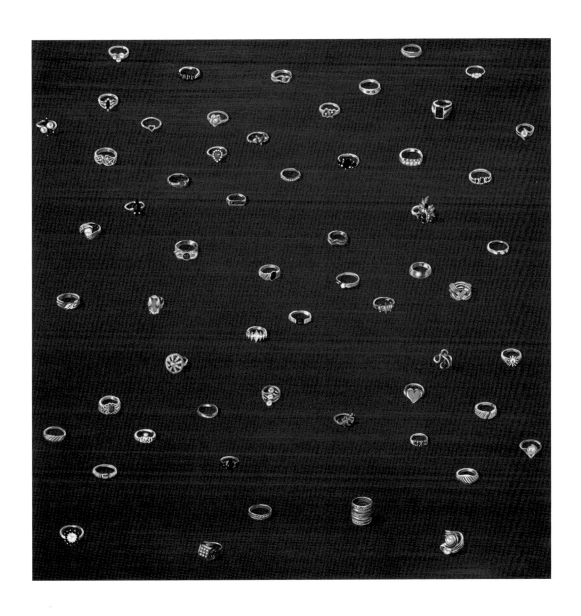

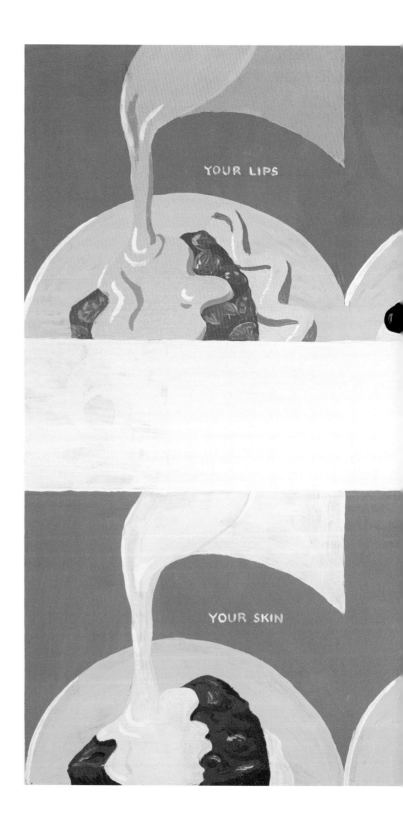

Six Flavours, 1992
Enamel on wood
15 x 20"
Collection of the artist, New York

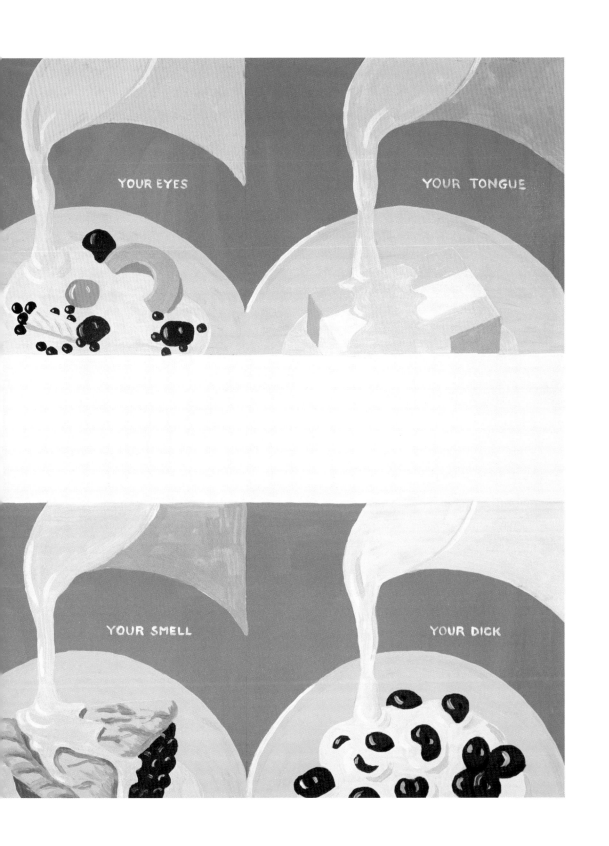

Cake Mixes, 1994
Enamel on wood
22.5 x 16"
Collection of Jean-Yves Noblet, New York

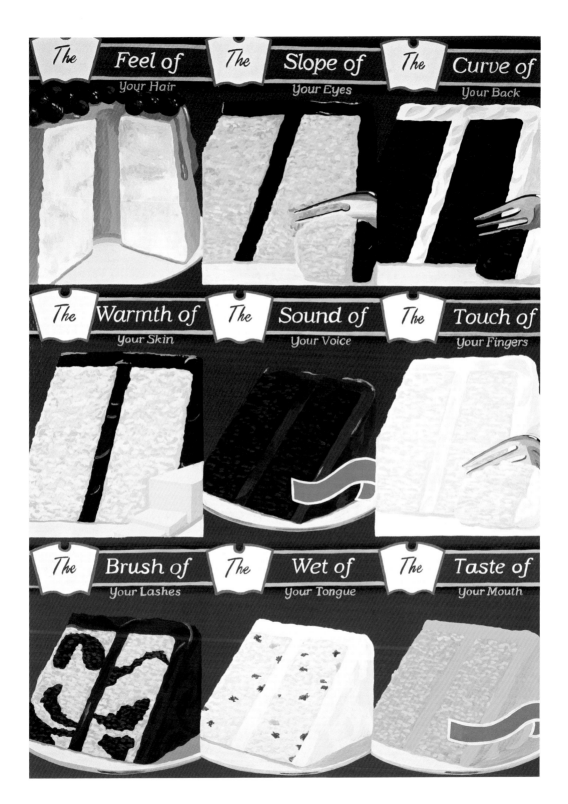

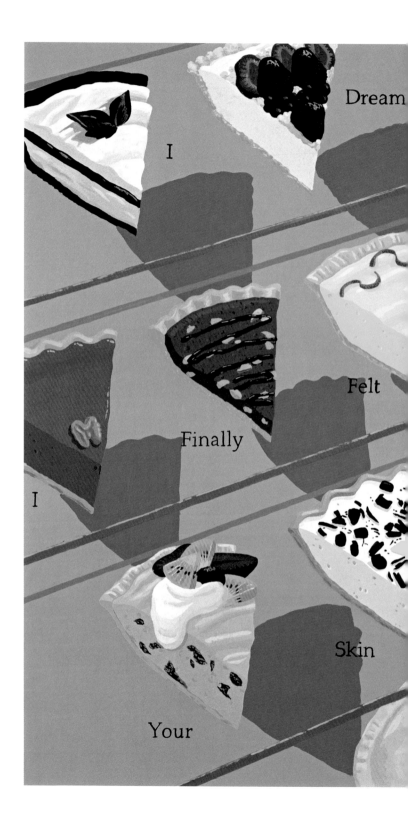

I Dreamt, 1995
Enamel on wood
24 x 32"
Collection of Norman Dubrow,
New York

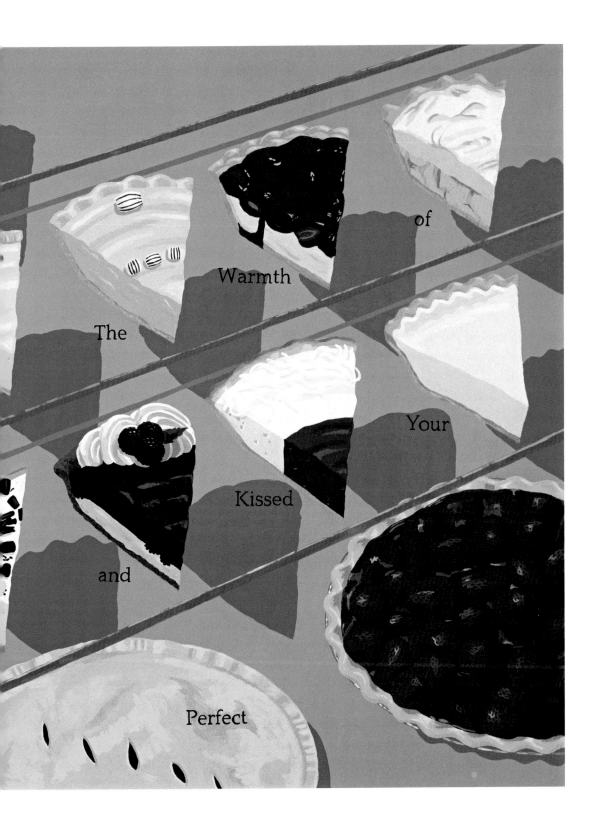

The Warmth of

Your

and Kissed

Perfect

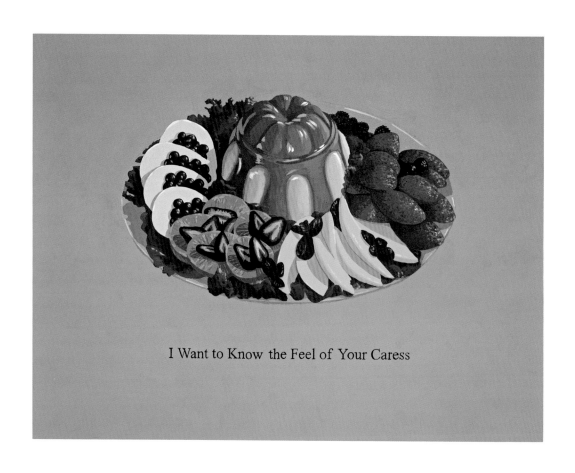

I Want to Know the Feel of Your Caress

Fruit and Jello Platter, 1997
Enamel on wood
22 x 28"
Collection of the artist, New York

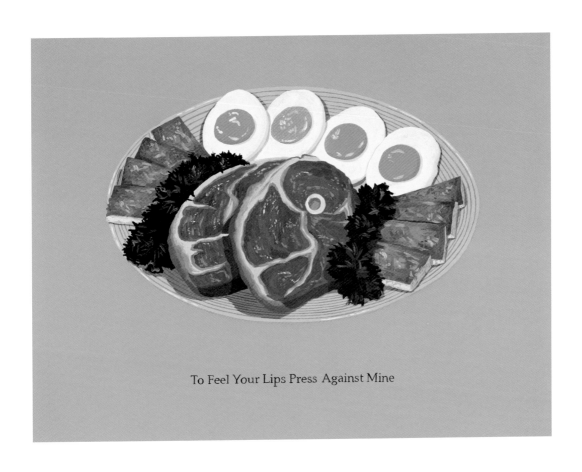

To Feel Your Lips Press Against Mine

Lips Press (Ham and Eggs), 1997
Enamel on wood
20 x 26"
Collection of the artist, New York

If

I

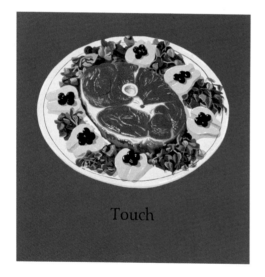

Touch

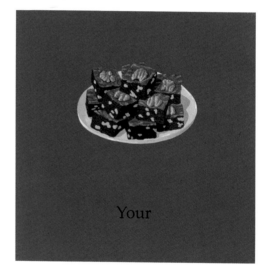

Your

If I Could Only, 1998
Oil on wood in eight parts
Each panel 20 x 20"
Collection of the artist, New York

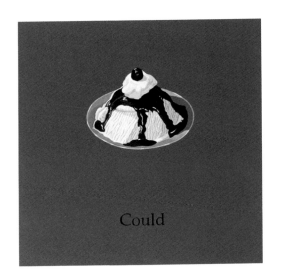

Could

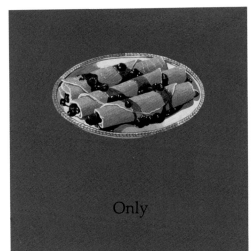

Only

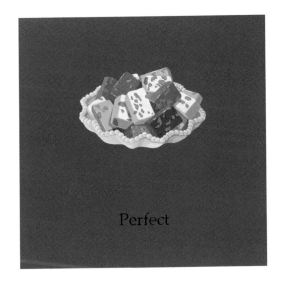

Perfect

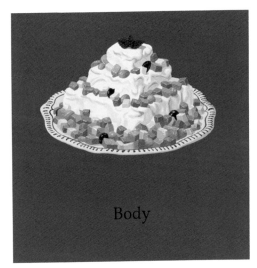

Body

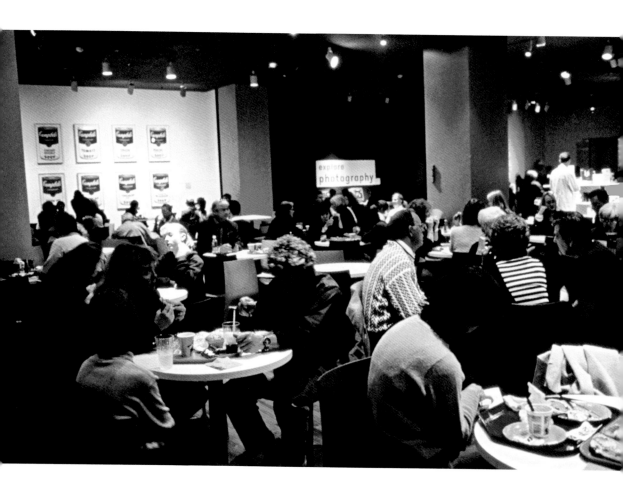

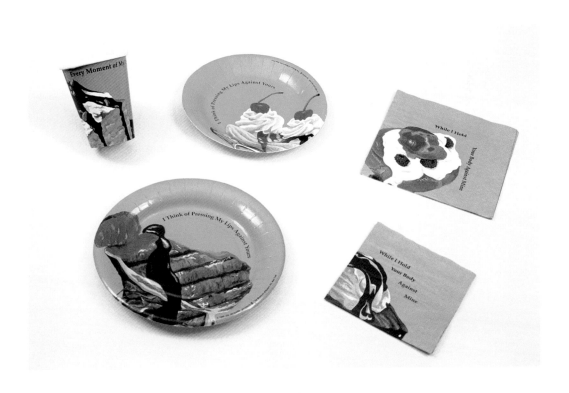

Projects 69: Julia Jacquette, 1999 (detail)
Printed paper products
Various dimensions
Unlimited edition designed for the
Museum of Modern Art's *Café/Etc.,* New York

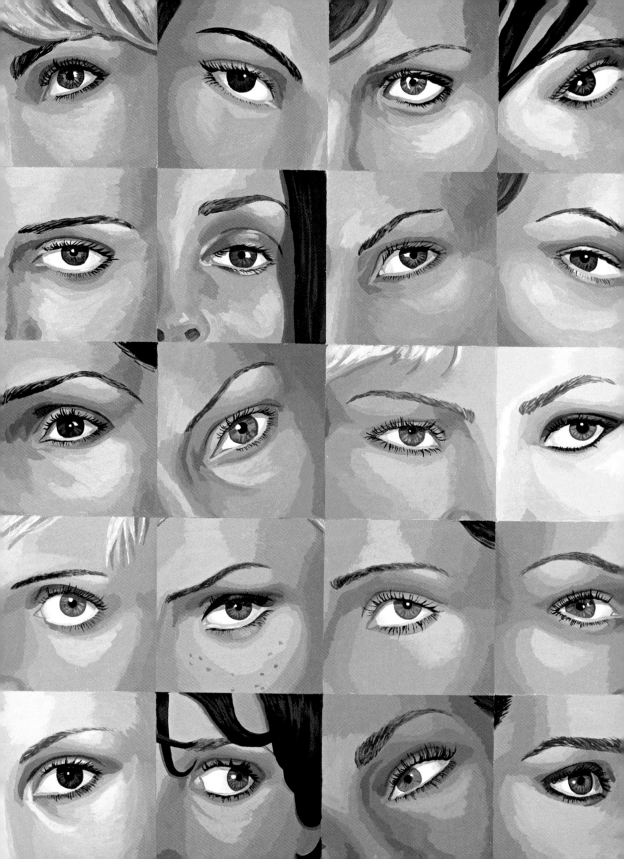

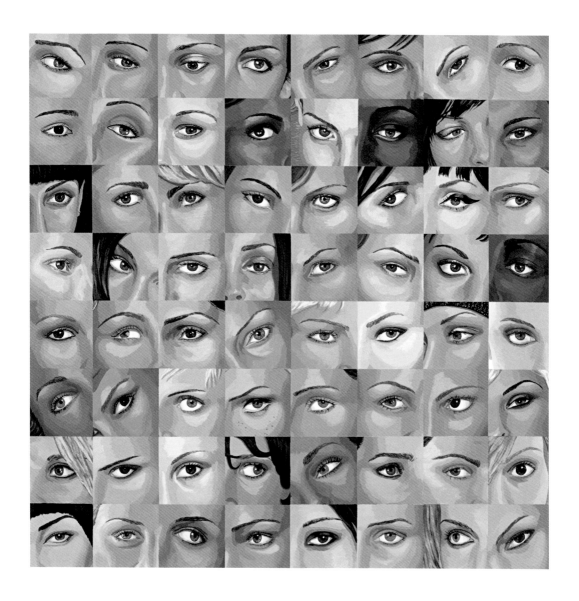

Sixty-Four Ladies' Eyes
(One with Glitter Cap), 1996
Enamel on wood
32 x 32"
Collection of the artist, New York

Some Men (Beer Glasses), 1998
Gouache on paper
7 x 22.5"
Collection of the artist, New York

Women: Sad, Worried (Self Portrait), 1999
Oil on linen
30 x 30"
Collection of Suzanne Julig
and John Keene, New York

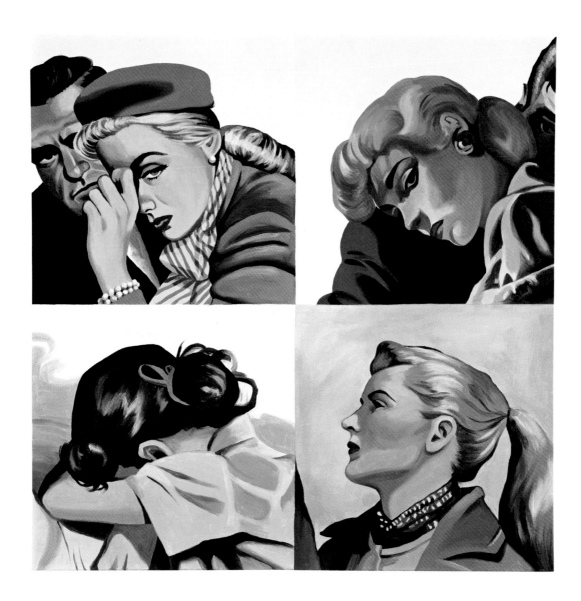

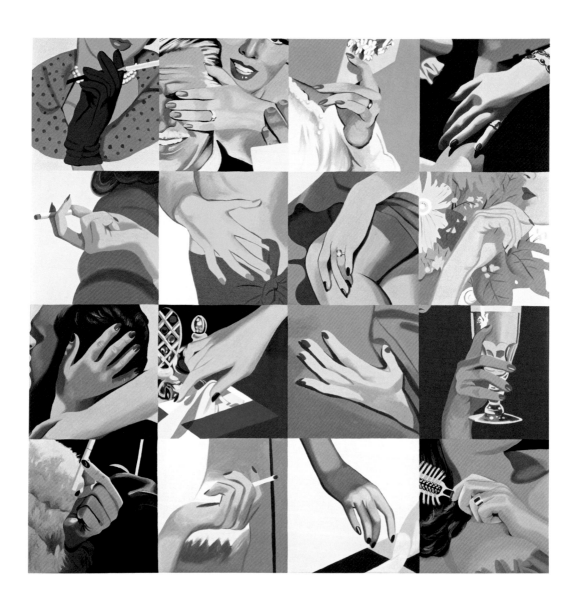

Women's Hands (Hair Brush), 2001
Oil on linen
48 x 48"
Collection of Bobbie and Stephen Rosenthal

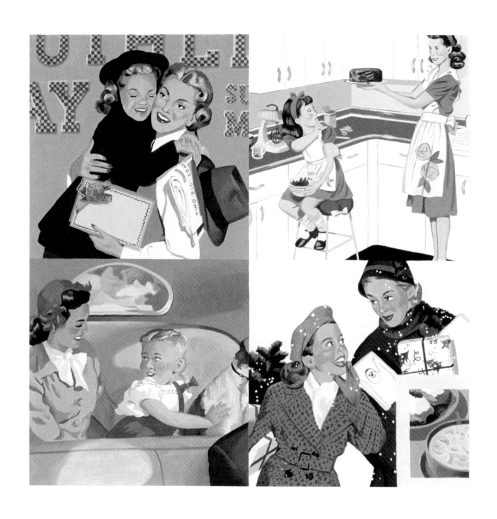

Daughters, Mothers II, 2000
Oil on linen
30 x 30"
Collection of Lisa and Richard Perry,
New York

Couples Embracing (Eyes Closed), 1999
Oil on linen
72 x 72"
Collection of Luciano Lanfranchi

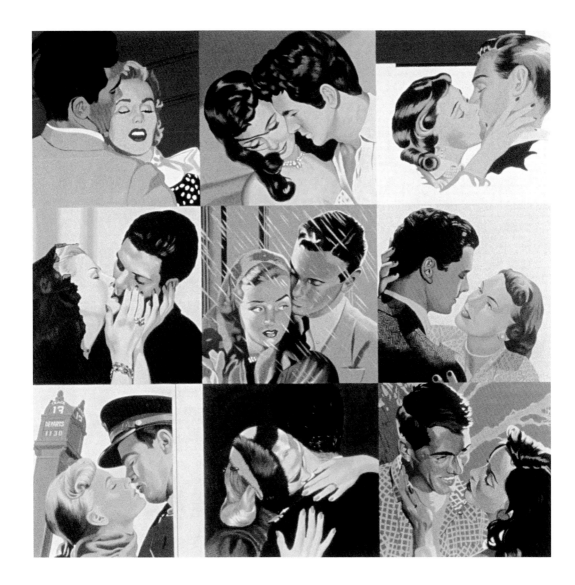

White on White (Wedding Dresses) II, 2002
Oil on linen
72 x 72"
Collection of Arthur Zeckendorf

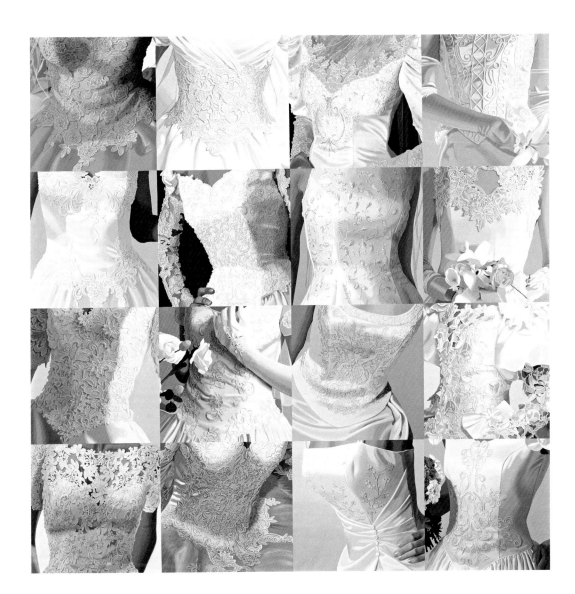

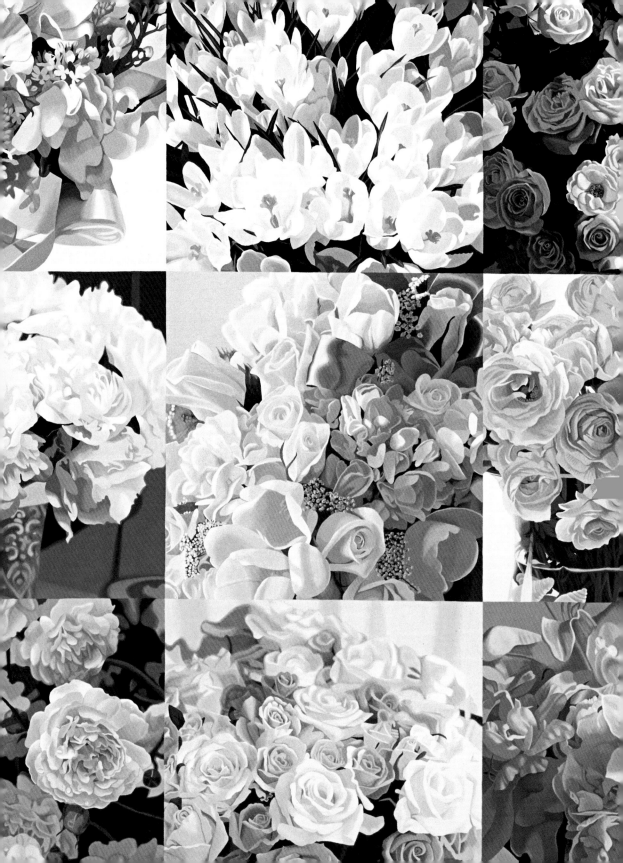

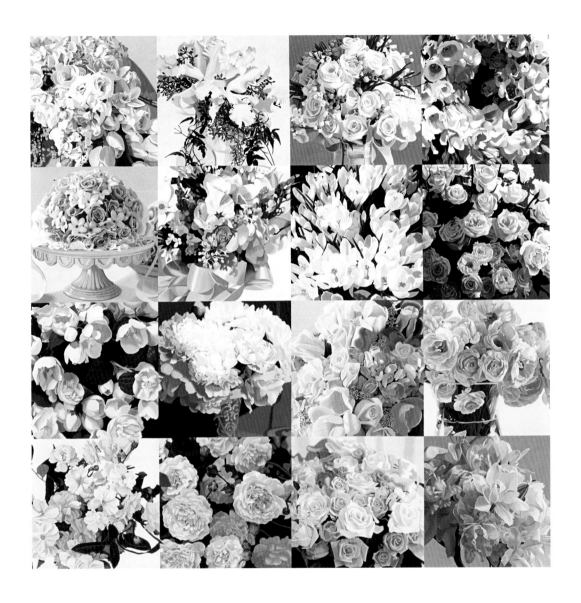

White on White (Sixteen Kinds of Flowers), 2002
Oil on linen
64 x 64"
Private collection

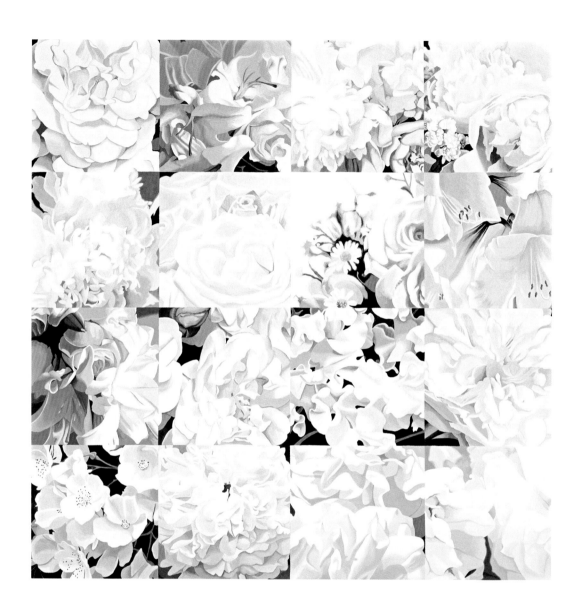

*White on White (Sixteen Kinds
of Flowers)*, 2002
Oil on linen
24 x 24"
Collection of Blair Woodward
and Bill Ayres

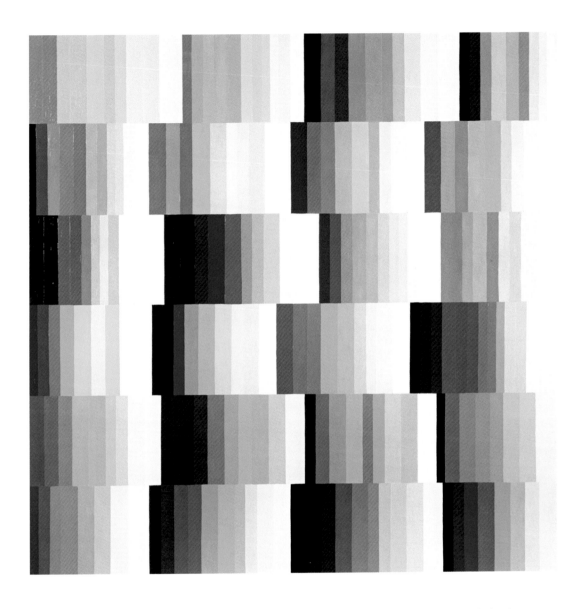

Geometric Painting (Colors from White Flowers), 2002
Oil on wood
24 x 24"
Courtesy of the artist and
Michael Steinberg Fine Art, New York

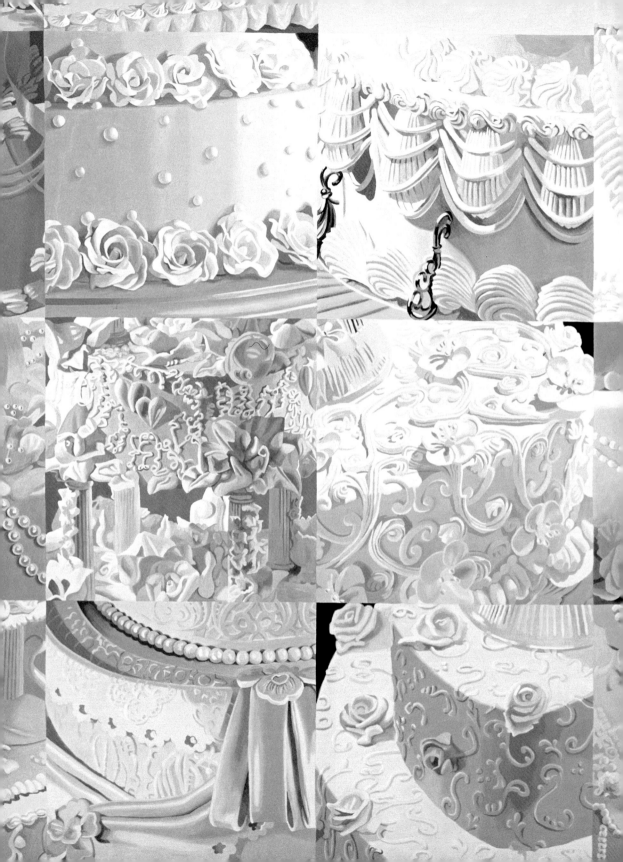

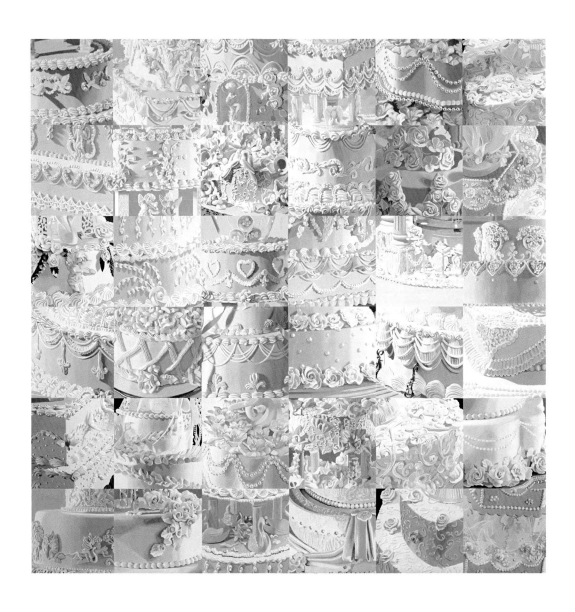

White on White (Thirty-Six Sections of Wedding Cake, Swans), 2003
Oil on linen
48 x 48"
Collection of A.G. Rosen

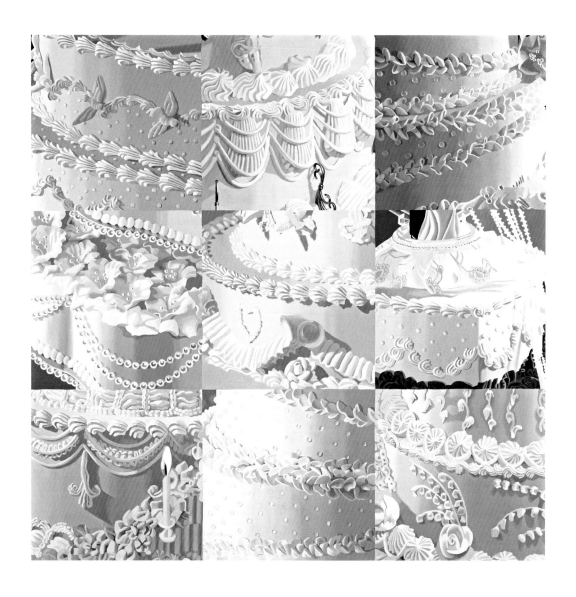

White on White (Nine Sections
of Wedding Cake, Candle), 2004
Oil on linen
24 x 24"
Collection of Lisa Schiff

*Geometric Painting (Colors
from Wedding Cakes) II,* 2003
Oil on wood
12 x 12"
Courtesy of the artist and
Michael Steinberg Fine Art,
New York

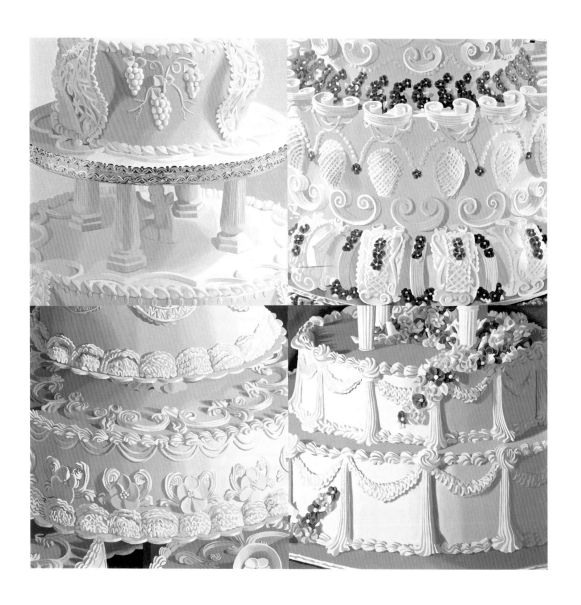

*White on White (Four Sections
of Wedding Cake),* 2001
Oil on linen
24 x 24"
Collection of Ann Tenenbaum
and Thomas H. Lee

Geometric Painting (Colors from Wedding Cakes) III, 2003
Oil on wood
12 x 12"
Courtesy of the artist and
Michael Steinberg Fine Art,
New York

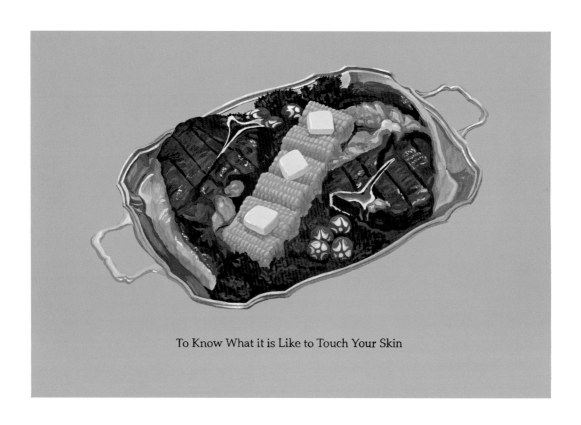

To Know What it is Like to Touch Your Skin

Touch Your Skin (Steak Platter), 1997
Enamel on wood
20 x 28"
Collection of the artist, New York

All works by Julia Jacquette, all dimensions in inches h x w x d

Paintings

1. *Six Flavours*, 1992
Enamel on wood
15 x 20"
Collection of the artist, New York

2. *Cake Mixes*, 1994
Enamel on wood
22.5 x 16"
Collection of Jean-Yves Noblet,
New York

3. *I Dreamt*, 1995
Enamel on wood
24 x 32"
Collection of Norman Dubrow,
New York

4. *A Watched Pot*, 1995
Enamel on wood
31.5 x 22"
Collection of the artist, New York

5. *Sixty-Four Ladies' Eyes
(One with Glitter Cap)*, 1996
Enamel on wood
32 x 32"
Collection of the artist, New York

6. *Fruit and Jello Platter*, 1997
Enamel on wood
22 x 28"
Collection of the artist, New York

7. *Hot Dog Platter*, 1997
Enamel on wood
20 x 28"
Collection of Michael Corman
and Kevin Fink, Dallas, Texas

8. *If I Could Only*, 1998
Oil on wood in eight parts
Each panel 20 x 20"
Collection of the artist, New York

9. *Couples, Touching*, 1999
Oil on linen
72 x 72"
Collection of Evan Koopman
and Jeffrey Fairbanks, New York

10. *Daughter, Mothers II*, 2000
Oil on linen
30 x 30"
Collection of Lisa and
Richard Perry, New York

11. *White on White (Wedding
Dresses II)*, 2002
Oil on linen
72 x 72"
Collection of Arthur Zeckendorf,
New York

12. *White on White (Four Sections
of Wedding Cake)*, 2001
Oil on linen
24 x 24"
Collection of Ann Tenenbaum
and Thomas H. Lee

13. *White on White (Sixteen Kinds
of Flowers)*, 2002
Oil on linen
24 x 24"
Collection of Blair Woodward
and Bill Ayres

14. *White on White (Thirty-Six
Sections of Wedding Cake, Swans)*,
2003
Oil on linen
48 x 48"
Collection of A.G. Rosen

15. *Geometric Painting (Colors from
Wedding Cakes) I*, 2003
Oil on wood
12 x 12"
Courtesy of the artist and Michael
Steinberg Fine Art, New York

16. *Geometric Painting (Colors from
Wedding Cakes) II*, 2003
Oil on wood
12 x 12"
Courtesy of the artist and Michael
Steinberg Fine Art, New York

17. *Geometric Painting (Colors from
Wedding Cakes) III*, 2003
Oil on wood
12 x 12"
Courtesy of the artist and Michael
Steinberg Fine Art, New York

18. *White on White (Nine Sections
of Wedding Cake, Candle)*, 2004
Oil on linen
24 x 24"
Collection of Lisa Schiff

Prints, all collection of the artist

19. *Four Sweets*, 1995
Silkscreen
18.5 x 27.5"

20. *To Kiss Your Lips*, 1998
Etching in four parts
10.5 x 10.5" each

21. *Projects 69: Julia Jacquette*, 1999
Printed paper products
Dimensions variable

22. *Men's Hands, Smoking*, 2000
Iris print
9.5 x 9.5"

23. *Women's Hands, Smoking*, 2000
Iris print
9.5 x 9.5"

24. *White on White (Four Sections
of Wedding Cakes)*, 2001
Etching
18.5 x 18.5"

25. *Four Pieces of White*, 2003
Etching and aquatint in four parts
7 x 7" each

26. *Couples Embracing (Green Hat)*,
2003
Iris print
16.5 x 16.5"

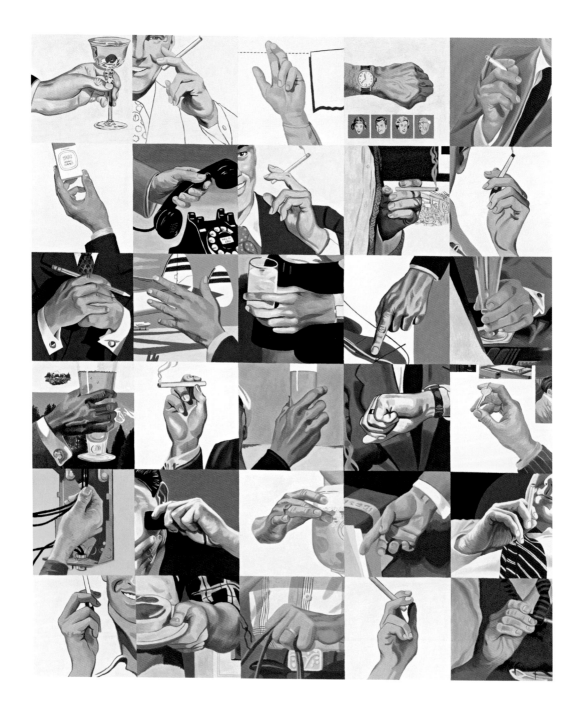

JULIA JACQUETTE

Born in New York, New York in 1964
Lives and works in New York, New York

Education

1992
M.F.A., Hunter College, New York, New York

1986
B.S., Skidmore College, Saratoga Springs, New York

1985
Skowhegan School of Painting and Sculpture, Skowhegan, Maine

Solo Exhibitions

(Exhibitions are followed by dates where available.)

2004
I Dreamt, The Tang Teaching Museum and Art Gallery, Skidmore College,
 Saratoga Springs, New York, June 26–September 5
White Paintings, Michael Steinberg Fine Art, New York, New York,
 March 5– April 3

2001
Virtues and Vices, Judy Ann Goldman Fine Art, Boston, Massachusetts,
 March 1–31

2000
Smoking, Galerie Oliver Schweden, Munich, Germany, May 10–July 1

1999
Projects 69: Julia Jacquette, Museum of Modern Art, New York, New York,
 November 22–Spring, 2000
Holly Solomon Gallery, New York, New York, April 8–May 8

1998
Paintings, Galerie Oliver Schweden, Munich, Germany, May 19–July 4

Puff by Puff, 1998
Oil on canvas
72 x 60"
Collection of Sharon and
Thurston Twigg-Smith,
Honolulu, Hawaii

1997

Works on Paper, Holly Solomon Gallery, New York, New York,
February 13–March 13

Cohen Berkowitz Gallery for Contemporary Art, Kansas City, Missouri,
November 7–December 27

1996

Holly Solomon Gallery, New York, New York, September 25–November 2

1995

Every Boy I Ever Dreamed About, Motel Fine Arts, New York, New York,
December 2–January 2

Open Space Series, Holly Solomon Gallery, New York New York,
February 25–March 11

1994

Every Boy I Ever Dreamed About, David Klein Gallery, Birmingham, Michigan,
August 4–August 27

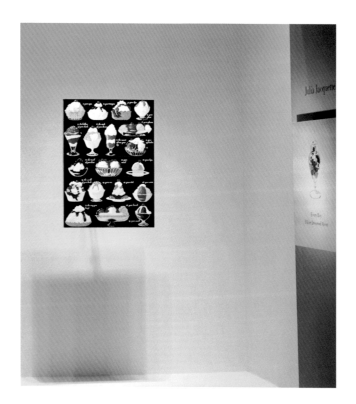

*Every Boy I Ever Dreamed
About,* Installation view,
Motel Fine Arts, New York,
1995

Selected Group Exhibitions

2003
The Burbs, DFN Gallery, New York, New York, June 4–August 29
Sweet Tooth, Copia: The Center for Wine, Food & the Arts, Napa, California,
 January 31–May 12

2002
Artists to Artists: A Decade of the Space Program, Ace Gallery, New York,
 New York, May 17–June 1
Second Sight, Hunter College/Times Square, New York, New York,
 February 27–April 20
Super Natural Playground, Marella Arte Contemporanea, Milan, Italy,
 February 6–March 23
Subject Matters, Kravets/Wehby Gallery, New York, New York,
 January 12–February 9

2001
Making Visible The Invisible, Schick Gallery, Skidmore College,
 Saratoga Springs, New York, November 8–December 16
Before They Became Who They Are, Kravets/Wehby Gallery, New York,
 New York, January 13–February 10

2000
Friendships in Arcadia: Writers and Artists at Yaddo in the 90's, Art in General,
 New York, New York, April 15–May 20, traveled to The Hyde Collection and
 Art Museum, Glens Falls, New York, May 28–September 4

1999
Little, Jeffrey Coploff Fine Art, New York, New York, December 3–January 9
Distilled Life, Bard College, Annandale-on-Hudson, New York, October
 5–October 31
The Likeness of Being, D.C. Moore Gallery, New York, New York,
 January 12–February 5
Greater New York: New Art in New York Now, P.S. 1 Contemporary Art Center,
 Long Island City, New York, February 27–May 14
Food for Thought, New Jersey Center for Visual Arts, Summit, New Jersey,
 March 21–May 2
Pattern, James Graham & Sons, New York, New York, June 24–August 27

1998
Think Pink, La Mama La Galleria, New York, New York
Food Matters, E.S. Vandam, New York, New York
Eat!, Museum of Contemporary Art, Sydney, Australia

Wishful Thinking, James Graham and Sons, New York, New York,
 July 16–September 11

Food for Thought: A Visual Banquet, D.C. Moore Gallery, New York, New York,
 June 24–August 12

The Next Word: Text and/as Image and/as Design and/as Meaning, Neuberger
 Museum of Art, State University of New York, Purchase, New York,
 September 20–January 31, 1999

1997

Drawn and Quartered, Karen McCready Fine Art, New York, New York,
 September 4–October 18

Alive and Well, Elizabeth Harris Gallery, New York, New York,
 September 13–October 18

Sex-Industry, Stefan Stux Gallery, New York, New York, February 8–March 23

1996

Hearts Desire, Judy Ann Goldman Fine Art, Boston, Massachusetts,
 December 18–January 25

Menu Du Jour, Daniel Silverstein Project Space, New York, New York,
 March 7–March 30

Eccentricities, Judy Ann Goldman Fine Art, Boston, Massachusetts,
 February 14–March 16

Home is Where the Art is or Hybrid Affairs, The National Arts Club, New York,
 New York

The Strange Power of Cheap Sentiment (or A Bientot to Irony), White Columns,
 New York, New York, October 25–November 27

1995

City Folk, Holly Solomon Gallery, New York, New York, December 16–
 January 20, 1996

Domestic Bliss, Margaret Roeder Gallery, New York, New York, March 10–April 29

Still Life, James Graham and Sons Gallery, New York, New York, May 11–June 30

1994

Little Things, Art In General, New York, New York, March 12–April 30

1992

M.F.A. Thesis Exhibition, The Gallery at Hunter College, New York, New York,
 December 7–January 6

Douglas Anderson and Julia Jacquette, P.S. 122 Gallery, New York, New York

Small Works, Washington Square East Galleries, February 1–March 13

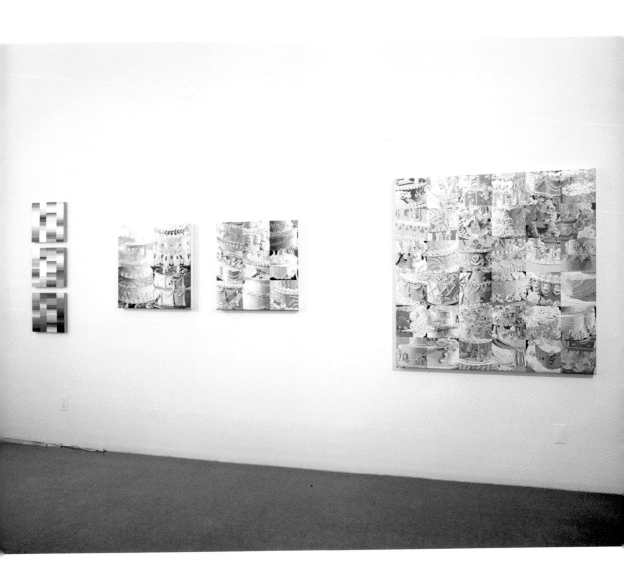

White Paintings, Installation view,
Michael Steinberg Fine Art,
New York, 2004

BIBLIOGRAPHY

Selected Catalogues and Brochures

Arning, Bill. *Julia Jacquette.* Exhibition catalogue. New York, New York: Holly Solomon Gallery, 1996.

Frankel, David, ed. *Artists to Artists: A Decade of The Space Program.* Exhibition catalogue. Colorado Springs, Colorado: The Marie Walsh Sharpe Art Foundation, 2002.

Drucker, Johanna. *The Next Word: Text and/as Image and/as Design and/as Meaning.* Exhibition catalogue. Purchase, New York: Neuberger Museum of Art, State University of New York at Purchase, 1998.

Hecker, Judith B. *Projects 69: Julia Jacquette "The Iconology of Food, Glorious Food."* Exhibition brochure. New York: Museum of Modern Art, 1999.

Moody, Rick et al. *Friendships in Arcadia: Writers and Artists at Yaddo in the '90s.* Exhibition catalogue. Saratoga Springs, New York: The Corporation of Yaddo, 2000.

Editrice, Silvia. *Super Natural Playground.* Exhibition catalogue. Milan: Marella Arte Contemporanea, 2002.

Tanguy, Sarah. *Sweet Tooth.* Exhibition catalogue. Napa, California: Copia: The American Center for Wine, Food, and the Arts (in Association with Marquand Books), 2002.

Selected Articles and Reviews

Arning, Bill. "Sleeping with the Avantgarde." *Time Out New York,* no. 32 (1 May 1996): 17.

Bee, Susan and Mira Schor, eds. "Working Conditons: A Forum on Art and Everyday Life by Younger Artists: Julia Jacquette." *M/E/A/N/I/N/G,* no. 16 (November 1994): 15–16.

Bee, Susan & Mira Schor, eds. "Ripple Effects: Painting and Language: Julia Jacquette." *New Observation,* no. 113 (12 December 1996): 14–15.

Bischoff, Dan. "A Matter of Taste." *Sunday Star-Ledger* (4 April 1999): section 4, p. 5.

Chen, Aric. "Bridal Party." *Surface,* no. 44 (Winter 2003): 248.

Colby, Joy Hakanson. "Sweet Stuff." *The Detroit News* (19 August 1994).

Corn, Alfrend. "Julia Jacquette at Holly Solomon Gallery." *ARTnews* (December 1996): 122.

Cotter, Holland. "Home is Where the Art is." *The New York Times* (2 August 1996): C18.

Dalton, Jenniffer. "Julia Jacquette at Holly Solomon Gallery." *Art Review* (15 October 1996): 11–12.

Diehl, Carol. "The Likeness of Being." *ARTnews,* vol. 99, no. 4 (April 2000): 164.

Echlin, Hobey. "Lips Like Sugar." *Metro Times* (4 August 1994).

Fabricant, Florence. "Paper Plate Art at the Modern." *The New York Times* (1 December 1999).

Hill, Shawn. "Sex and Sensibility." *Bay Windows* (16 January 1997): 30.

Hill, Shawn. "The Body as Battlefield." *Bay Windows* (2 February 1996): 25.

Johnson, Ken. "Art in Review." *The New York Times* (16 July 1999).

Levin, Kim. "Home is Where the Art is or Hybrid Affairs." *The Village Voice* (23 July 1996): 9.

McQuaid, Cate. "Ad Lib." *The Boston Globe* (22 March 2001).

McQuaid, Cate. "Sexualized Salami." *The Boston Globe* (2 January 1997).

McQuaid, Cate. "Eccentricities Nicely Mixes it Up." *The Boston Globe* (3 March 1996).

Miro, Marsha. "Men are just desserts to painter." *Detroit Free Press* (8 August 1994).

Moody, Rick. "Art is Dead, Long Live Art!" *Modern Painters,* vol. 11, no. 1 (Spring 1998): 80–81.

Parsons, Susan. "Where Art Captures the Flavour of Food." *The Canberra Times* (27 May 1998).

Scobie, Ilka. "Domestic Desire." *Cover* (December 1996): 40–41.

Smith, Roberta. "Palette Full of Ideas About What Painting Should Be." *The New York Times* (1 November 1996): C27.

Smith, Roberta. "Art in Review." *The New York Times* (9 February 2001).

Thorson, Alice. "Here's an Exhibit to Savor." *The Kansas City Star* (12 December 1997): 24.

Vine, Richard. "Julia Jacquette at Holly Solomon." *Art in America* (January 1997): 94.

Williams, David. "Julia Jacquette at Holly Solomon Gallery." *NY Soho Arts Magazine* (4 November 1996): 9.

Zimmer, William. "A Feast Where Not Everything Looks Good Enough to Eat." *The New York Times,* New Jersey Section (18 April 1999).

ACKNOWLEDGEMENTS

I Dreamt is the first solo exhibition at The Frances Young Tang Teaching Museum to feature the work of an alumni artist. We are pleased that Julia Jacquette, class of 1986, could be that artist and also the seventh in our ongoing series of *Opener* exhibitions. Her conflation of suggestive texts and advertising images is rooted in a Pop tradition, yet is also driven by the artist's specific emotions and desires. This self-revealing layer is one that draws in many viewers and has inspired a Master's class on the ritual of marriage. The class was offered at Skidmore during the course of her exhibition and is just one example of how this project was a catalyst for dialogue in the galleries.

Julia Jacquette's work is included in many private collections throughout the country, and we are pleased that so many of them have agreed to lend works to this exhibition—thanks to Norman Dubrow, Jean-Yves Noblet, Michael M. Corman and Kevin Fink, Lisa and Richard Perry, Evan Koopman and Jeffrey Fairbanks, Blair Woodward and Bill Ayres, Arthur Zeckendorf, A.G. Rosen, Lisa Schiff, Thomas H. Lee and Ann Tenenbaum, and Michael Steinberg Fine Art. The *Opener* series is one of our most popular and important endeavors at the Tang, and its continued success is due in great measure to the funders of the series. Special thanks to The Laurie Tisch Sussman Foundation, The New York State Council on the Arts, The Overbrook Foundation, and the Friends of the Tang for their support.

Michael Steinberg in New York has been a great help with this project. Thanks to him and the staff at Michael Steinberg Fine Art: Karen LaGatta, Liz Raizes, and Sarah Ryhanen, for their assistance with loans and catalogue details. Thanks to Bethany Johns who has designed another wonderful volume in the *Opener* series with many photographs by Bill Orcutt. At the Tang Museum, thanks to our installation crew: Sam Coe, Abraham Ferraro, Torrance Fish, Steve Kroeger, Dan O'Connor, Alex Roediger, Jay Tiernan, and Joseph Yetto. Thanks to the hard working Tang staff: Ginger Ertz,

Lori Geraghty, Elizabeth Karp, Susi Kerr, Gayle King, Chris Kobuskie, Barbara Schrade, Gretchen Wagner, and Nicholas Warner. Also thanks to Barbara Melville, Mary Jo Driscoll, Sarah Goodwin, and Barry Pritzker for their support, and museum interns Brendon Boyle, Clare Cosman, Graham Keegan, Ginny Kollack, Jason Lombardi, Jen Mergel, and Kimiko Nakamura.

Lastly, thanks to Julia Jacquette for bringing her warm presence into the museum. She was a constant help with research and images and lent several works from her personal collection. Most importantly she shared her humour, honesty, and careful critique of our contemporary society during the course of this project, and we are most grateful. —IAN BERRY, Curator

Julia Jacquette studio view
New York, 2004

This catalogue accompanies the exhibition

OPENER 7

JULIA JACQUETTE: I DREAMT

The Tang Teaching Museum and Art Gallery at Skidmore College
Saratoga Springs, New York
June 26 – September 5, 2004

The Tang Teaching Museum and Art Gallery
Skidmore College
815 North Broadway
Saratoga Springs, New York 12866
T 518 580 8080
F 518 580 5069
www.skidmore.edu/tang

This exhibition and publication are made possible in part with public funds from the New York State Council on the Arts, a state agency, The Laurie Tisch Sussman Foundation, The Overbrook Foundation, and the Friends of the Tang.

ISBN 0–9725188–5–1
Library of Congress control number:
2004111756

Designed by Bethany Johns
Printed in Germany by Cantz

Front Cover:
Joan, 1991 (detail)
Oil on wood
24 x 24"
Collection of the artist, New York

Back Cover:
A Watched Pot, 1995
Enamel on wood
31.5 x 22"
Collection of the artist, New York

p.1: Julia Jacquette studio view
New York, New York

Photographs:
Front and back cover, pages 2, 16, 17, 18–19, 24, 25, 26-27, 30–31, 33, 35, 36, 41, 43, 44, 45, 47, 48, 49, 50, 51, 52, 59:
Bill Orcutt
Page 1, 63: Julia Jacquette
Pages 4, 22–23: James Shanks
Page 21: Britt Bunkley
Page 28: Tom Griesel